ADVENTURES WITH ADOPTABLE DOGS

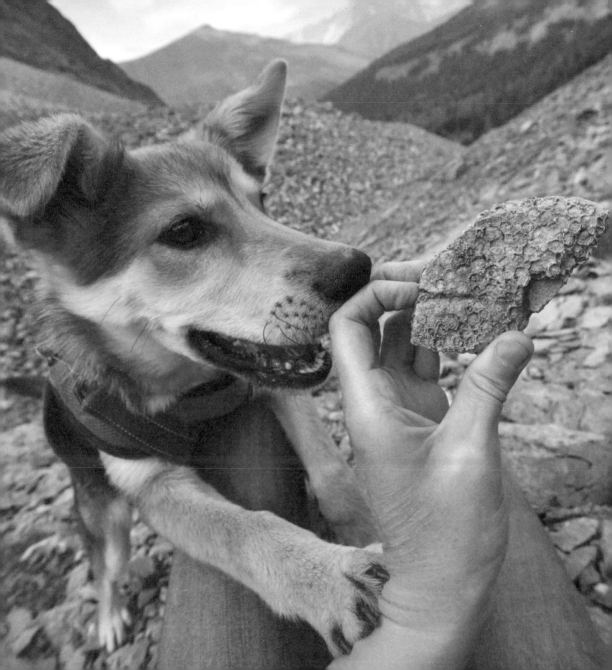

ADVENTURES WITH ADOPTABLE DOGS

An INSTAGRAM GUIDE for ANIMAL ADVOCATES

RACHAEL RODGERS · @TRAILSANDBEARS

RMB

For information on purchasing bulk quantities of this book, or to obtain media excerpts or invite the author to speak at an event, please visit rmbooks.com and select the "Contact" tab.

RMB | Rocky Mountain Books Ltd.
rmbooks.com
@rmbooks
facebook.com/rmbooks

Cataloguing data available from Library and Archives Canada
ISBN 9781771603799 (paperback)
ISBN 9781771603805 (electronic)

All photographs are by Rachael Rodgers unless otherwise noted.

Printed and bound in Canada

We would like to also take this opportunity to acknowledge the traditional territories upon which we live and work. In Calgary, Alberta, we acknowledge the Niitsitapi (Blackfoot) and the people of the Treaty 7 region in Southern Alberta, which includes the Siksika, the Piikuni, the Kainai, the Tsuut'ina and the Stoney Nakoda First Nations, including Chiniki, Bearpaw, and Wesley First Nations. The City of Calgary is also home to Métis Nation of Alberta, Region III. In Victoria, British Columbia, we acknowledge the traditional territories of the Lkwungen (Esquimalt, and Songhees), Malahat, Pacheedaht, Scia'new, T'Sou-ke and W̱SÁNEĆ (Pauquachin, Tsartlip, Tsawout, Tseycum) peoples.

We acknowledge the financial support of the Government of Canada through the Canada Book Fund and the Canada Council for the Arts, and of the province of British Columbia through the British Columbia Arts Council and the Book Publishing Tax Credit.

to the strange, relentless humans
who insist on showing animals
that life can be wonderful

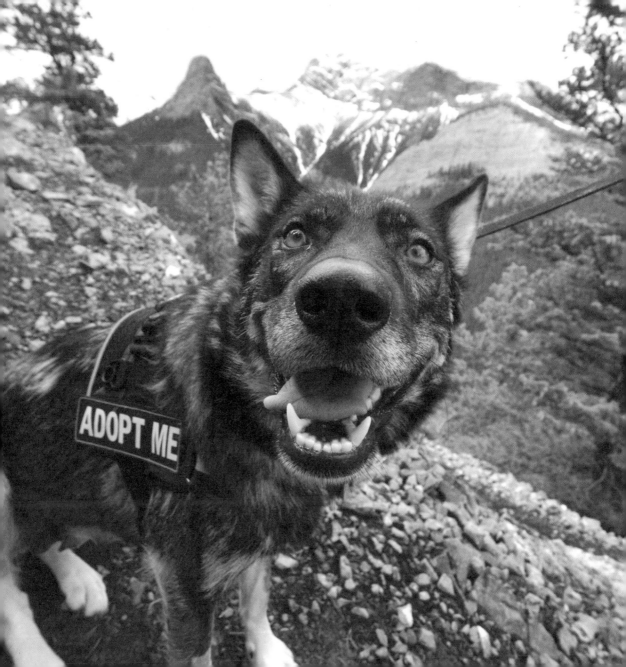

ADOPT ME

CONTENTS

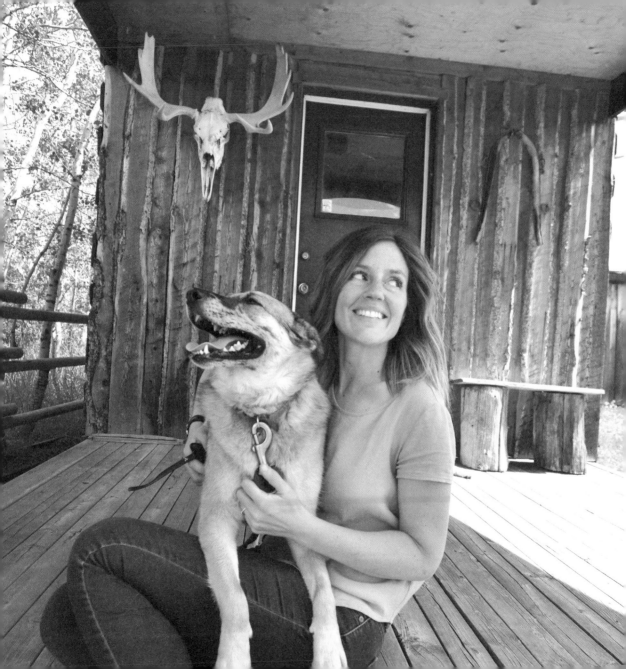

PREFACE

"How is this dog such a good girl, if she's from a shelter?"

—A MESSAGE I RECEIVED ON INSTAGRAM
REFERRING TO A DOG IN MY STORY.

In that one line, the sender summed up a big part of *why* I do what I do. Shelters are *full* of good girls and good boys, but a lot of people don't know that. There's a harmful misconception that dogs in shelters must have something wrong with them and an equally harmful misconception that if you get a dog from a breeder then you "know what you're getting." Every dog (and human) has their idiosyncrasies, no matter where they come from.

My mission is to help people see, without ever having to go into a shelter, the amazing dogs surfing through the shelter system in a way that shifts the general thinking in our society in favour of these dogs.

We domesticated dogs, but then somewhere along the way we abandoned our societal responsibility to care for them properly. Ideally, the number of dogs in the world would be equal to the number of dogs who are wanted. While I have many ideas and opinions about this, the first step is for us to realize and admit there's a problem with the way our society consumes pets. Every day I see the price paid, not by society, but by forgotten animals.

SOCIAL MEDIA FOR ADOPTABLE DOGS

Animal rescue organizations always have their plates full with the day-to-day tasks involved in caring for animals, maintaining the facility, and keeping the doors open to animals in need. Social media may be a bit of a mystery and is often placed far down on the list of priorities. With some simple techniques used to make deliberate posts, social

media has the potential to greatly improve the way dogs find homes. I've spent much of the last two years volunteering with a variety of animal shelters and their foster families. I've been using photography, along with Instagram and Facebook, to learn how social media exposure can help a dog find a home. With the free reach and information sharing provided by these tools, adopters get to make better-informed choices and dogs can more easily be linked with homes that suit their character.

While there are a lot of great "just for fun" social media accounts for animals, I want to help shelters and volunteers have a bigger online presence. If volunteers created more content, we could start to really harness the power of social media for animals who need the exposure.

I'm writing this guide to help you skip the trial and error stage and get right to the essentials of what I've learned about social media and volunteering. The advice in this guide is based on my first-hand experience with rescue organizations, adopters, adoptable dogs, and benefits afforded to them all by social media.

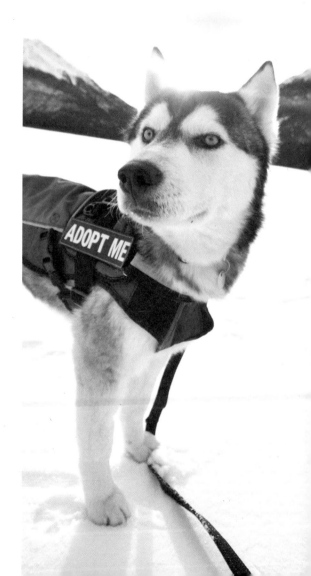

THREE EASY STEPS FOR GETTING A DOG ADOPTED

Advocating for animals may feel over-whelming, but as one person you can do a great deal just by following these three steps. Throughout this guide I'll expand on each step.

1. #VOLUNTEER

If you're not already a volunteer at your local shelter, head to their webpage and sign up today. Many places have multiple rescue organizations to choose from, so find one where your particular skills and time will make the most difference. If you have an idea for helping that isn't listed on their sign-up sheet, let them know how you want to help.

2. #PUPFOLIO

When you take a dog out for a walk/hike/drive/expedition of any kind, take a lot of shots and videos of the dog dog-ing. There is a lot of information for potential adopt-ers in seeing how dogs conduct themselves during these seemingly mundane activities. Capture as many of these telling moments as possible. This will be the #pupfolio that you share across various social media platforms.

3. #POST

Put your best shots and videos on your Instagram in a 24-hour story *and* a post to help get your fur-friend seen by poten-tial adopters. There are ways to optimize a post to get the maximum exposure for the dog. After all the time you've spent on the first two steps, it's important to implement these methods to help you create a worthy post for your new friend.

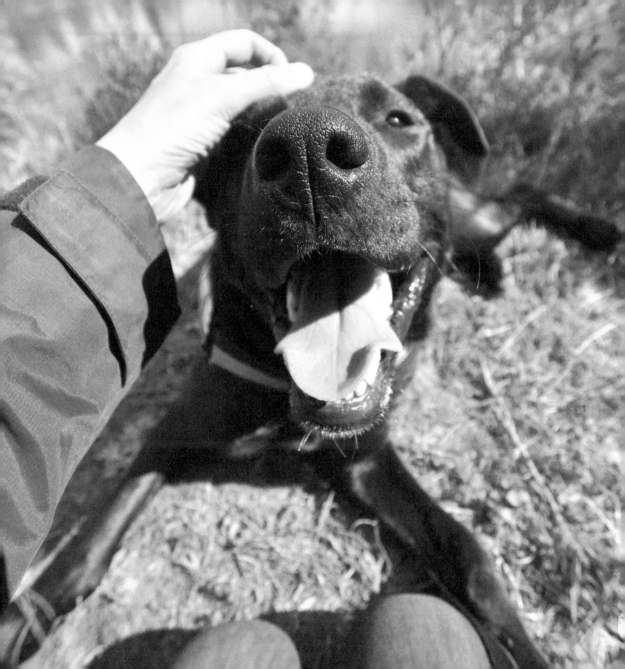

MAKING AND SHARING YOUR PUPFOLIO

HOW TO CREATE A PUPFOLIO

I firmly believe that no matter how weird the dog, there's a perfectly weird human out there looking for just such a friend. The biggest service we can do while posting on behalf of an adoptable animal is to represent his or her character accurately (no matter how odd).

As a volunteer or foster, you'll get to build relationships with adoptable dogs. It's inevitable that during the time spent together you'll get a glimpse into what makes the dog happy, what makes him/her reluctant, and what would (or wouldn't) fall onto a list of favourite activities. This is precisely the sort of information that can help match appropriate people with their perfect pup.

If you have the chance to meet adoptable dogs in shelters, take a little video or photo to show them living life in spite of their situation. Photos of dogs in shelters can help the public realize that shelters aren't full of scary dogs (and maybe even inspire them to visit/volunteer). It's amazing how many comments I get through my Instagram from people who are so surprised to see so many lovely pups available for adoption – despite the fact that shelters are teeming with really cool pups!

WHERE AND HOW TO SHARE YOUR PUPFOLIO

You don't need thousands of followers on Instagram or all the friends on Facebook to give a voice to adoptables. When you post your fur-buddy on Instagram, be sure to *tag*, geotag and hashtag the shelter.

Adeline is the perfect example. Adeline, an adoptable buddy I posted on @trailsandbears, was up for adoption through Pawsitive Match Rescue Foundation in Calgary, Alberta. I

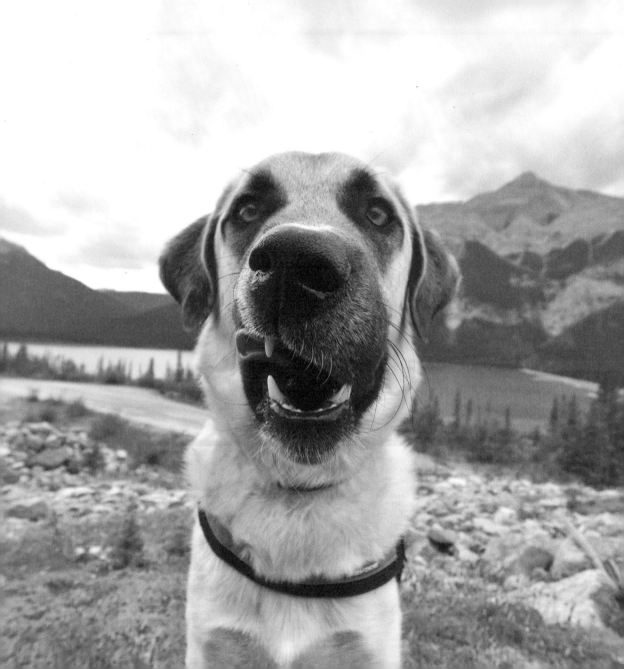

tagged her photo "@pawsitivematchrescue," used #pawsitivematchrescue in comments, and added the geotag "Pawsitive Match Rescue Foundation." If anyone in my audience is looking to adopt, this tells them where Adeline is and also allows the rescue organization to easily repost my post for greater exposure for Adeline (which they did). When posting on Facebook, the same goes for "checking in" at the actual rescue organization, not just the town it's in. In this example, I used "Pawsitive Match Rescue Foundation" as the Facebook location. You should also mention them in your post by starting to type their name immediately after @." When the right name pops up, just click on it and it will appear in bold so you know they will be notified of the post and your audience will have a direct link to the rescue. The administrators on the rescue organization's Facebook page are then easily able to share your post of the adoptable pup. By including these small bits of info, you've just helped your adoptable friend and the rescue organization be seen by all your followers as well as all the people who have no idea who you are but follow the rescue organization; that's a huge boost for the dog!

WHAT TO INCLUDE AND OMIT IN AN ADOPTION POST

Include the animal rescue organization as the geotag or "location" at the top of the photo. Use the shelter even if the photo wasn't taken there. This signals to the reader that this post is more than just a fun dog photo and may entice further reading.

Include the @tag of the host shelter in the caption. This allows the reader to get on their Instagram page (which usually has a link to their website) with a single click. Good traffic directing is about making desired actions clear and simple to follow.

Organize your hashtags after your post.
- The first hashtag after the caption summing up the status of the dog: #adoptable, #foster or #volunteer.
- The second hashtag naming the shelter where your audience can find this dog.
- Add a third hashtag naming the closest large city. This is especially valuable info if the shelter doesn't have a geotag or an Instagram account.

Build your caption with love and care! Add info about how this dog is unique and great. What does this dog bring to the table that would make the right human lucky to have him or her for life? Make sure to include age.

You've taken lots of photos and videos for your pupfolio, so make sure you're sharing the ones that best represent your bud. Instagram is a visual platform. You can be darn sure the visuals play a big part in the post's effectiveness. Try to capture clear images/videos. It also helps to find the best background possible. Think: hikes, forests, urban jungles, parks, car rides. Remember, visual platform: if the photo stinks, the whole post kinda stinks and won't entice your audience to read about the awesome pup you're highlighting. The pup deserves great visual representation. (This doesn't mean you need to buy expensive camera gear, but more on that later.)

An adoption post should not include breed. Try to describe the dog's unique character. Naming a breed can elicit stereotypes or memories of an experience that has nothing to do with this dog. It's useless, or worse, harmful information. I've met several purebred dogs that are extremely unique within their breed. Even if I believed breed was a useful descriptor, it would be a moot point, as most adoptable dogs don't have the foresight to come into the shelter with their genetic lineage papers in paw. But again, even if they did, I leave genetic makeup out of it, since we can attain and deliver much more reliable information about a dog's behaviour by spending some time with them and watching how they behave.

An adoption post should omit the dog's past experiences (unless the dog is a retired sheep herder, fire rescue dog, movie star, or some other info that describes their talents or activity level). Telling a sad story about a dog's circumstances introduces irrelevant information. If the dog has had a bad life, that speaks to the humans who misused that dog, not the dog or his or her character. I never want someone to adopt a dog out of pity or guilt or sadness. I want someone to adopt because they fall in love with the animal (and vice versa) and know that they will live their best lives together based on compatibility of character and lifestyle goals (not looks, genetic stereotypes, or a sense of obligation because of a sad story).

ADOPTION POST DOS AND DON'TS

DON'T

- Whoops! Where's the geotag?

- I can't see the dog's face clearly, and she certainly doesn't look overly joyous, even though she may indeed be a joyous pup.

- Don't portray or describe a dog as "in need" or ask someone to "rescue." Guilt and pity have no place in important life choices like adopting a new family member. If you're at a loss for descriptive vocabulary, just give an accurate account of your time together.

- How old is the dog?

- Where would I find this dog? Use the @tag for the shelter in the caption *and* the photo.

trailsandbears ⊙

trailsandbears Look at this sad lonely dog. Come adopt her before she spends one more day alone. #rescueher

EXAMPLE OF *DON'T* ▲

DO

- Geotag as the shelter name. Check!

- Clear photo of a dog exploring, with eyes visible. Check!

- While not shown here, @aarcs is tagged in the photo.

- A caption that tells me the dog's name and describes some traits that she has to offer. Check!

- Using #adoptable at the end stands out and allows followers to clearly see at a glance that she's a dog who's available for adoption.

trailsandbears ●
Alberta Animal Rescue Crew Society - AA...

1/10

trailsandbears This is Prim. She just turned one year old. Prim is a relatively large puppy, but she is sweet and calm and reserved. She's a bit... unmotivated (which could be read as clumsy or lazy, but I wouldn't say that), which may contribute to her desire to refrain from physical activities that require much exertion (like hiking and getting into a car). Prim's foster human informed me that Prim doesn't go on long walks (usually less than 20 minutes). Not because Prim doesn't have the opportunity to go on longer walks, but because Prim doesn't have the desire to go on longer walks.
It's a good idea to trust the foster human, so I left the planned 10km hike un-checked in my notebook. Instead, Prim came for a custom driving/walking tour comprised of my favorite top-places-that-can-be-gotten-to-by-short-walks walks.
Being tied to Prim is about the same as I imagine it is to be tied to a donkey... I imagine it to be great fun as long as our desired velocity vectors* match exactly (*a phrase which here simply means arrows drawn with specific sizes (representing speed) and directions (representing direction)). Prim seemed to be thinking the same thing about being tied to me: that it's great fun in the same way that being tied to a donkey is great fun. We each made small compromises on both components of our desired velocity for a collection of many tiny walks in the mountains.
I brought species appropriate food for each of us, but after finishing her snacks, Prim ate a third of my PB&J croissant without asking if I was going to finish it (I was going to finish it). She hunched to peer from the car window at every opportunity and judged her situation constantly. She didn't say anything, which I think meant something like [these windows are too short for me to peer and judge from comfortably]. If you know someone who is as keen to hike as my lovely aunt Sandra back in New Brunswick and Prim (are both not really), let them know about her (Prim). She's available for a life time of sharing short walks and sandwiches. #adoptable @aarcs

GETTING CHARACTER-REVEALING PHOTOS **AND** VIDEOS

PHOTOS

A lot of people ask me about my photos. The first (and sometimes only) question is usually "What kind of camera do you use?" If I had to name only a handful of the most significant things that contribute to the kind of photos I love for my pupfolios, the camera I use wouldn't make the list. While I could have told you the cameras and lenses I prefer to use, that isn't the point.

First, don't stress about getting perfect photos and going into hours of post-click editing. Take many. You may notice that my photos are not usually technically perfect. Most of my photos aren't perfectly focused, composed, lit or edited, They are usually candid shots that I *hope* describe the feeling of a moment. This may seem contradictory to what I said before about Instagram being a visual platform, but it's not. Yes, if you can get technically great photos, you're ahead of the game, but more importantly, you want photos that make people *feel* positive emotions.

Having a DSLR with the ability to change lenses is important for photographers who have a certain style in mind, but it's not necessary for promoting adoptable, excited and happy pups. So what *is* necessary?

The dog must feel safe. If the dog feels life or limb is at risk, then you certainly aren't going to get photos or videos of their true character. Make a loose plan for the day but be flexible. Put the pup first; this is about helping them find the best home to live in for their *whole* lives. It's a pretty big deal for them. Be empathetic and make sure you aren't putting anything trivial before the pup's interests and needs.

Connect! Try to find out what kind of nut you're dealing with and show that nut to your followers. Offer a good quality stick

or invite the pup to run with you for a few seconds. Ask him or her to do some basic tricks for snacks – if they know the commands, it will help them realize that they have a way to communicate with you (which helps them feel confident, secure and happy). Connect before you start taking pictures!

Background. Find a background that's pleasing to the eye but not distracting. Be creative in finding spots that will enhance the photo. A background that helps tell the story of your time together without taking the viewer's eye from the dog is key.

Perspective. There are a lot of perspective options that make interesting dog portraits. I usually like to have the camera at the level of the dog's head (just above or below can also give some neat angles). Another perspective I like to see is from my point of view (standing tall with the camera at my face) looking down at a dog who is sitting or standing right at my feet and looking up smiling. In this kind of shot, I show my feet so the viewer may even feel as though they

are standing there with the dog. All of this helps the viewer connect better with the dog.

Eyes. We connect through the eyes, so for most shots aim to have the eyes in view and in focus. If you don't have a bond with the dog, you may want to take a few minutes before the shoot to communicate with them. Try saying "What's this?" and immediately give them a small snack as soon as they look. Take some photos during this time so they can get used to hearing your camera's shutter noise and even pair it with the snack. You can also tie a squeaker to your camera strap and give it a squeeze when you're ready to take a shot.

Lighting. Everyone loves a sunny day, it seems. But sunny days are the worst for dog shots. The bright, direct light creates harsh shadows on a dog's face and in the background. My absolute favourite days for shooting are the ones that look like a storm is about to be unleashed (or might already be happening). Overcast is better than direct sun, as the sun's rays are scattered by

the cloud layer, which lights your subject from many angles, eliminating shadows. Puffy clouds with definition are even better, because they scatter the light and add drama to the photo's appearance. There may be times when you meet an adoptable dog and perfect storm clouds are nowhere to be seen. If you have the perfect subject on a sunny day, make the best of it by finding a place with full shade for the dog, the background and the foreground.

Shoot Manual. If you're shooting with an SLR, shoot in manual. If you're not sure how it all works, practise (and then never stop practising). These cameras have many, many options, and the right settings are personal for each shooter. Once you figure out what look you like to see in a photo, you'll have no trouble getting it when shooting in manual with the lens of your choice. The only way to figure out your favourite shooting style is to practise. I tend to use a wide aperture (short focal depth) with a fast shutter speed (dogs move a lot, so I want to catch just an instant in time). If lighting is low, I'll turn the ISO up rather than

decrease my shutter speed below 1/400th of a second (unless it's an incredibly docile dog). I like to shoot with my white balance on auto. I find the camera does a great job of changing this in dynamic lighting conditions and it doesn't take any creativity away from my shot to leave this up to the camera.

Keep your Rights. When you sign up to volunteer, read the waiver carefully; many waivers will ask you to give exclusive photo rights to the rescue organization for any shots you take while volunteering. You do not have to do this. Raise a concern with the volunteer coordinator about it, or simply cross it off on the waiver and make a note that you will keep the rights to your photos, but that the shelter may certainly use or share any photos given to help the dog get adopted.

VIDEOS

Videos convey *so* much more than photos; they are an invaluable way for you to reveal the dog's character. It won't matter if you're not the best cinematographer or the most descriptive writer if you just take a few videos of the dog being himself or herself in

different common situations – eating a meal, walking on a trail, playing with other dogs (if safe and if not against shelter rules), playing with you, being a passenger in the car, going through a drive-thru ... pretty much anything you can think of to show what this pup likes (or doesn't like). Videos give potential adopters information that may save them from adopting a dog who doesn't fit into their lifestyle and then having to re-surrender the dog, which can be a big mental setback for the dog and also for potential adopters. Videos can also help the perfect person realize this dog belongs in their life.

I will often reach for my phone to record surprise video opportunities. I use an action camera for showing the whole situation (they have wide-angle lenses). It helps to show the situation so the viewer can imagine himself or herself there and can see the dog being themselves in that particular environment. I sometimes use a selfie stick to get the camera far enough away from the pup and me to show what's going on, but often my arm does the trick. The feeling, the impression, of being there with the pup will usually elicit some kind of feeling for potential adopters. Whether the feeling is positive or negative, it's helpful for adopters to recognize and use this information to make a decision for (or against) adopting that dog.

Bonus tip: Most pups will exchange attention to the camera for snacks. Make it clear that you're paying when you have a camera in hand; most of them aren't fools.

PORTRAIT VERSUS LANDSCAPE

Since Instagram is meant to be viewed on phones in a portrait (versus landscape) orientation, you will find it helpful to shoot vertically for your entire pupfolio. If you still prefer landscape, that's fine; a horizontal orientation has its advantages too. Whichever you choose, take all your photos and videos in the same orientation. This will avoid all the cropping of vertical and horizontal content you'll need to do if you're mixing orientations in the same post. (You can put up to ten photos and/or videos in one Instagram post.)

VS.

POSTING VERTICAL CONTENT (VS. HORIZONTAL)
TRANSLATES INTO GREATER VIEWING AREA
OF YOUR PHOTO ON SMART PHONES

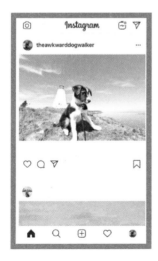

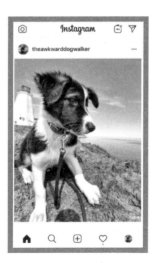

RESPONSIBILITY AND SAFETY ON FIELD TRIPS

Advocating for your adoptable buddy on a day out is imperative. You may have just met this dog, so work on building a positive bond by chatting, giving snacks (especially in exchange for any tricks they may know), and being responsive if they tell you they are too anxious or need a break from the drive.

Mental Health Tip: If they're getting anxious from being on the road for too long, pull over somewhere quiet and get out for a little walk. Take this time to build a stronger bond.

Dogs are notoriously bad at advocating for themselves, so you must be their voice. You're the leader for the day. You're responsible for the dog's well-being – both physical and mental. One way you will need to keep the dog safe is by not allowing strangers (people or dogs) to get too close. This is called advocating for the dog's space. For the sake of everyone's physical safety and mental well-being (especially your new buddy's) you should ensure there are no interactions with anyone but you. When you see or hear people approaching on a trail, move off the trail far enough that a surprise burst extension of the leash won't allow contact. Since you don't have a history with your hiking friend, you can't be certain how they will react to humans of various shapes and sizes or the animals who may accompany them. A dog can tell when you're in control and will feel more comfortable. The opposite is also true. A dog may appear friendly and excited to interact, but today with strangers isn't the way to test this. Most shelters have volunteers sign waivers so they aren't liable if anything happens while handling an animal in their care. You can just think of other hikers as not having signed that waiver, so you need to protect the dog and the shelter at these times. I like to clearly, loudly,

and politely let people know that the dog I'm with is on a field trip from a shelter and can't say hi today. I've never had anyone react to this information with anything but respect for our space and warm well-wishes for the dog. Remember that dogs are unpredictable, and if the dog reacts on a trail because of your lack of advocacy for their space, that could be very bad for the dog and the shelter even though it's not the dog's or the shelter's fault. *It's so important to be responsible in order to ensure this type of volunteering is able to continue and for more shelters and rescue organizations to start allowing field trips. Please remember to word your advocacy in a polite and friendly manner – not everyone out there loves dogs, and you're speaking on behalf of everyone who brings a dog into public spaces.*

TIPS FOR SHELTER ADMINISTRATORS

There are many adamant supporters of animal rescue in every community. A social media page for your local animal rescue organization will grow a *good* following without doing anything, but with mindful, deliberate posts, your organization can grow a *great* following and build a strong connection to your community. The goal is to bring meaningful information to this audience and get people (outside this core, dedicated, default group) involved.

Great posts on animal rescue accounts include (but are not limited to):

- a high-quality photo of a happy/playful/ loving/smart/unique animal for adoption or fostering
- a follow-up story and photo of an animal who has found a wonderful forever home
- a volunteer or foster parent highlight that includes information about their unique way of helping animals.

Sharing this information is a great way to recruit new volunteers from your online supporters. It may come as news to your audience that volunteers help the animals in many different ways and that the shelter is in need of helpers.

"User-generated content" on Instagram (photos/posts created by someone else that help deliver your message) from volunteers with adoptables is invaluable to shelters that can share and repost this content to the shelter's social media accounts. It helps followers (potential volunteers, fosters and adopters) imagine themselves in useful roles and helps showcase adoptable animals.

You can find user-generated content on Instagram for a shelter by searching the shelter's common hashtags, the shelter's geotag or the photos that were tagged with the shelter's account. Find current applicable content and share, making sure to credit the original poster for the photos and the volunteering. This will inform your audience further about volunteer opportunities and show your current volunteers that their work is valued.

Sharing on Facebook is similar. When the shelter is tagged in applicable posts, hit "share," then "share to a page." Crediting your volunteers for their contributions is so important. If your volunteer waiver asks volunteers to sign away their rights to their photos, consider rewording this to ask for the right to share their content on social media with the proper photo credit. It helps your volunteers feel a sense of community and contribution.

In order to get more user-generated content to share, encourage your volunteers and fosters to post on social media using the integral elements of an adoption post listed earlier.

Don't be afraid to ask your followers and volunteers to share their ideas. There's so much work to be done at animal shelters that any operational help, and especially any innovative ideas to make adoptions more efficient and effective, should be welcomed.

You might have followers who are able to help with something you haven't even thought of yet!

A COLLECTION OF
ONCE HOMELESS DOGS
ON ADOPTION ADVENTURES

Here is a small collection of the ridiculous, skeptical, brilliant, loving, stubborn, enthusiastic and oftentimes silly dogs I've gotten to spend time with, photograph and speak for. Many of these dogs were discovered and adopted through online exposure.

This is Isabel.

When I met her at @aarcs in her kennel, she gave me fair warning that her pageant talent is "escape." I like a challenge and so I agreed to judge this talent for myself. I'll skip the stressful part and admit that I rated her a 10 on both style and speed. Fast forward a few hours, many phone calls and one large team-building exercise, and Isabel found herself exhausted and very pleased with herself at home with me in Canmore. She came to spend a night with Beans and Denali and do a little sightseeing before the deep freeze.

She showed no sign of wanting to escape (after proving she could). She was so calm in the car that we went right through Banff National Park to Yoho National Park in British Columbia.

She was interested in everyone she met. As human sightseers complimented me on my beautiful dog, I explained that she's available for adoption. She would follow up with a dorky-but-beautiful smile and a demonstration of her less glamorous talents like "sit" and "shake." These talents impressed the humans and many wanted to take her home, but none were in a position to do so.

If you know someone who would love this talented lass, she is resting up at @aarcs for her next adventure.

Isabel and many of her pals are available for fostering or adoption. #adoptable

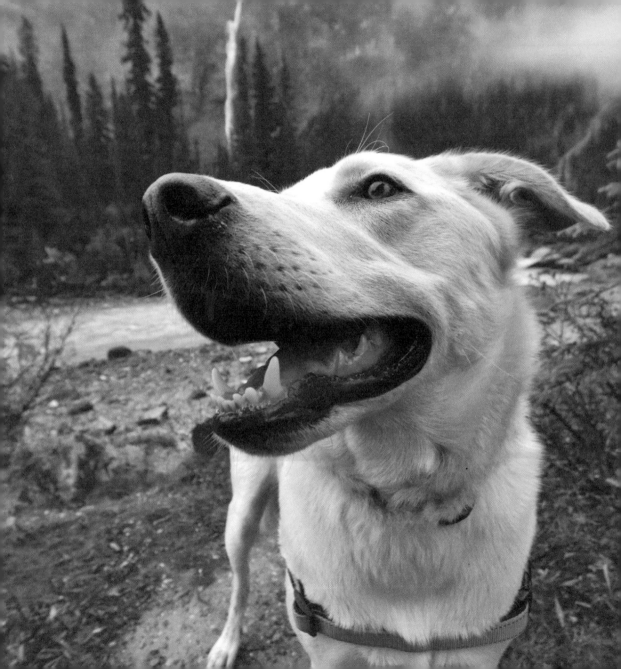

This is Marley.

She's only 2 years old but she can walk backwards. If that's not enough to solicit the snacks from your pocket, you should also know that she's a professional squirreller. She can spot a grey squirrel, a ground squirrel, a red squirrel, even a chipmunk, from 900 paces. (She has a little harder time with the ground squirrels because they're so sneaky with their alarm calls.)

Marley went to Banff with me for a hike in the rain. We made our way up "the mountain where the water falls" (the original name of Cascade Mountain) through the remnants of what was a coal mine a century ago. Marley explored the foundations that remain and definitely wanted to head into the mine openings, but there's a fence around them all just tall enough to discourage her. When we got close to the cirque (our spot to eat sandwiches) we heard avalanche after avalanche. The warm, rainy day created the perfect slide weather. We picked a safe spot and ate some lunch while watching the snow come down the mountain. On the descent, Marley pointed out all

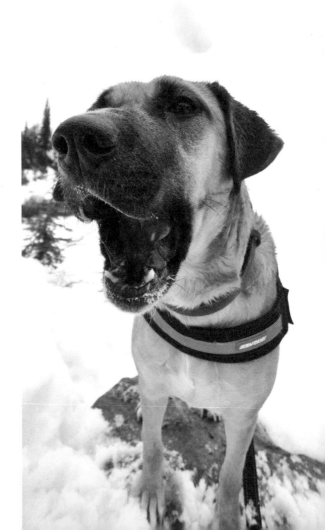

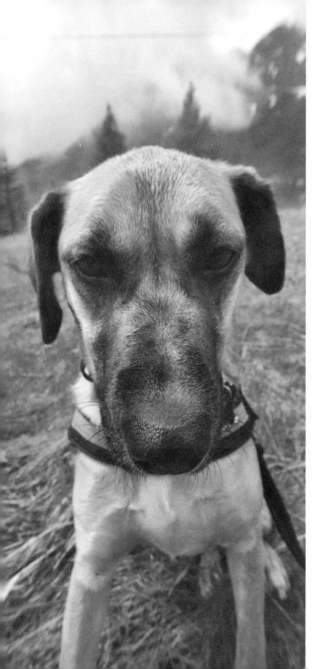

the squirrels with her swiftly moving whole body. She was excited to say hi to (i.e., jump on) any hikers who were informed of her preferred greeting and still wanted to say hi.

Do you know someone who would love a dog who loves people and abandoned mine sites and squirrels (of all types)? Marley is waiting to find the perfect home with humans who love her features. She's available from @arfalberta in Calgary. #adoptable

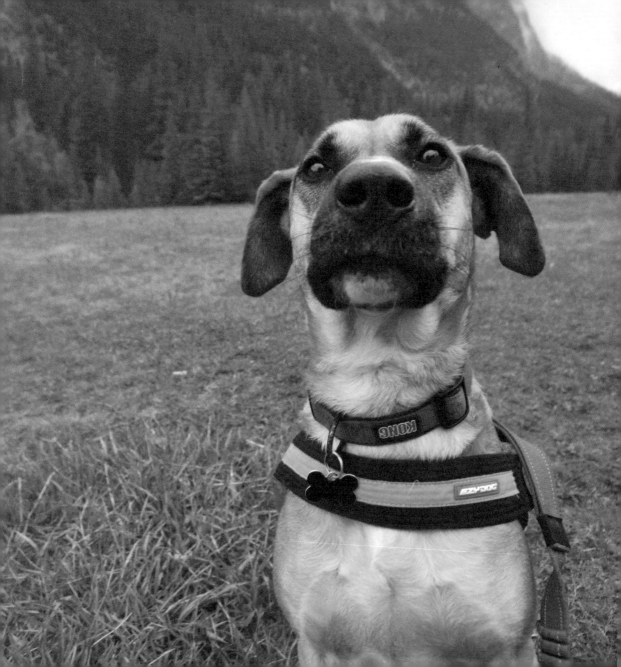

This is Estrella.

Estrella has been going by "Star" recently. I couldn't get a clear answer from her on whether she'd like to go with a fresh start or if she identifies with her name that came here with her from her motherland. She doesn't seem to have strong feelings one way or the other.

Star is 2 years old and *loves* to play with other dogs. When I picked her up from her foster dad, she was playful and jumped into my car with one hop and zero hesitation. She immediately searched out, found and asked for a snack. We went for a walk by the creek, where she tracked elk and chipmunks with the same enthusiasm. She watched birds in flight closely and wanted to follow every critter's scent track by ground – especially the tracks through places under thick brush where I didn't fit (or didn't want to fit). She stepped into the water a few times to take a drink and cool her skin. Her skin seems pretty irritated, perhaps from the dry Alberta air, or from her recent thorough washings and transportation stress (I hope she likes planes and airports more than I do). It looked like the cool water was soothing.

After our exploration at the creek, we went to see Beans and Denali. She was immediately ten times happier and thought about writing her own book [*How to Immediately Increase Your Happiness 10x*]. "Increase the number of dogs in your surroundings" was really her only suggestion, so probably no need for a book.

She's extremely food driven, but she never guarded her food or behaved aggressively with Beans and Denali at snack time. She watched them inquisitively as they performed odd behaviours seemingly in exchange for their snacks. She surely could learn all those odd behaviours very quickly, but she doesn't know them at the moment.

If you know someone who would love to learn some of Estrella's culture (and teach her some Albertan culture) please alert them to this lifelong opportunity. Star is currently in foster care, and her adoption is through Rocky Mountain Animal Rescue in Calgary. #adoptable

This is Anna (formerly Storm). I picked this monster up from Garcia Rescue for adoption photos Saturday and kept her overnight. By Sunday she had chewed through my best harness and leash, escaped the yard twice, and bit each of us several times. She's part fox, part cuddler and part bad manners. I filled out an application for her immediately and now she's staying. #adopted

Anna brings the house to life and brings Beans back from the light. She's too smart, and she's been through enough bad times to pen a dog version of *The Pursuit of Happyness*. She may act like a little poophead sometimes, but hers are completely understandable behaviours for a dog who did these things to stay alive. What's amazing is how quickly she extinguished these "bad" behaviours within just a day or two of bonding and training.

These last few months alone, Beans seemed to have packed his things, satisfied with the amount of life he's lived. Each mealtime has been a task involving hand feeding and pleading with him to eat. After meals, he puts himself to bed as if that's all there is. I try whatever I can think of to see a smile on the boy's face. Watching Beans try to keep up with Anna, tolerate her cuddles, go outside with her every chance and start eating voluntarily (almost eagerly) beside her makes me confident that he feels like he's got some living left to do.

And Anna: she is loved with all of my ability to do so. Of course, there are adoptable dogs I've fallen for before, but the image of a life with this dog was immediately as clear to me as a vacuum (which is absolutely clear).

We wanted to give this spirited little girl a good strong name to match her character. So she's called Anna after the very strong-willed and truly great human Anna who runs @garciarescue. If you know Anna (the human), you'll understand why Anna (the dog) is lucky to have her name.

This is Ben.

He's 1 year old. You can read about his past in his profile on Rocky Mountain Animal Rescue. There's no arguing that this little guy has been through it. But none of what he's endured defines him. His outstanding friendliness, patience and loyalty, *despite* what he's been through, defines Ben.

I had the pleasure of getting to know Ben yesterday. He was excited to meet me and introduce me to his friends at the shelter. I played for a few minutes there with a couple of happy pups, a situation I find difficult to leave. Then we headed into K-Country to attempt Grizzly Peak with human friends. I had explained to my friends that I didn't know how far Ben would or could make it, so we took a separate vehicle in case Ben was hesitant or tired. I didn't expect to make it far: this is a very steep hike that's not possible if the dog isn't an angel on leash, among other requirements. Ben showed no sign of weakness or defeat; I was extra vigilant about this. We made it about 90 per cent to the peak before I made the decision to turn back. I didn't want to exhaust loyal Ben even if he was willing. He happily drank the water I brought for him from my hand during a few rest stops.

We met lots of friendly faces on the trail and Ben loved the introductions (sometimes lying on the trail in very uncomfortable-looking spots just for pets and cuddles from strangers). The idea of climbing a mountain just to unclimb it is definitely new to Ben, but he embraced it. #adoptable

If you know someone who would love Ben, he can be found at Rocky Mountain Animal Rescue, chillin' with his buddies.

This is Gunnar.

He's between 1 and 2 years old and doesn't like riding in cars (or maybe just my car). Gunnar was playing with other pups at Garcia Rescue when I met him. He seemed jovial and energetic after a recent procedure that effectively stunted the Gunnar branch of his family tree. I wonder: Could it be liberating for him to no longer be completely inundated by the innate burden of passing his genes along?

Gunnar hopped into the car and we drove off, both realizing that we wanted to sit in the same seat. We pulled over and rigged up a harness to keep Gunnar out of the driver's seat. He was displeased. Gunnar showed extreme anxiety at not being allowed to sit on me while I drove. I told him I wished we could sit like that too, but also that it's quite dangerous. He displayed no ability to grasp this. He demanded some stops in odd places during the drive to the mountains. Just as the car was full to the brim with tension and anxiety, we arrived at our hike in Kananaskis. Gunnar was *so happy* to be there (or just to be not in the car). We broke our own trail in snow up to

Gunnar's belly to one of the coolest creeks around. I trudged along while Gunnar galloped, which seemed like the easiest gait in the depth of snow. An extra-long tether system, to which we were both harnessed, attached us so that we could both have all paws free. Gunnar likes to explore, but he also loves a kind touch. When he was extra anxious in the car, all it took to calm him was a hand on his paw. He would immediately stop barking and put his nose to my hand to keep it there. I think a big part of his car anxiety came from the forced separation. He did much better on the way back to Garcia Rescue.

If you know someone who would love a pup with eyes made to be photographed and a heart made for adventure and loyalty, let them know about this kind boy. Gunnar is available for adoption from @garciarescue. #adoptable

Gunnar would also love a temporary place to live while he waits for his forever family to discover him. #fosteringsaveslives

This is Matilda.

She's 1½ years old and her favourite toy is a magic pink platypus. Matilda is still young enough to know some things for sure:

1. Dogs are supposed to ride shotgun.
2. If a platypus is pink, it is a magic platypus.
3. All good girls get adopted to families who love love and fun.

Matilda's dedication to shotgun never wavered longer than the time it took to retrieve her magic pink platypus from the back. She probably outgrew shotgun more than a few weeks ago, but that's where dogs are supposed to ride with their human, regardless of comfort. She gazed at me while we traversed field after field. This was quite a different thing than a mountain drive. The dirt roads had nary a curve (the Confederation Bridge has a curve in it just to keep ya awake, but I suppose veering off would have lesser consequences out in these fields). This is where they say, "It's so flat you can watch yer dog run away for days." I didn't test that.

Once outside the car, Matilda stretched her legs and hauled me along excitedly as an eager child does a lacklustre parent. I held on tight for an early holiday ride as we bolted around the Badlands of Drumheller (and adjacent to some beautiful fields along the way). Matilda is full of awe and wonder for the world around her; it shows in her eyes as she moves through whatever makes up her day. If you know someone amazing who could use a reminder of the world's daily wonders, tell them about the wonderful Matilda and her magic pink platypus. Check her out at @aarcs in Calgary. #adoptable

This is Moose. He's a 12-week-old puppy and he acts exactly like one. After I picked him up, he immediately pooped in the car. I felt bad for not giving him enough outdoor time before the drive, so I pulled over to clean and took him for a little walk. We got home and I gave him some yard time, but he seemed like he was good. One minute later when we got inside he went again (no. 1 and no. 2 on two different rugs). I gave Moose a puppy bath just for peace of mind and then he clawed and chewed the one good sweater I had. Moose didn't seem to care about this. Beans is still trying to figure out if Moose is extremely dim or just a psychopath. I told Beans that Moose is a puppy and that's how they all come (not too bright). I reminded old Beans that he was once a puppy, and he still got a chance to shine as the sophisticated goober he is.

Post-bath, Moose napped with Beans and then with my partner, Mike (@mr_nice_guy79). #puppytherapy

Sleepy puppy Moose and I set out for an icy afternoon paddle. He was an excellent passenger. He slept most of the time, not demanding much supervision. The best part of his passenger-ing, though, happened after he got out of the kayak and had a big pee (I took a moment to really appreciate that he chose not to do that in the kayak). If you think this is too much talk about poop and pee (as I do), then that's a sure indicator that you shouldn't adopt a puppy. If you'd love nothing more than to teach this boy all the ways of the world and let him practise being a good boy by chewing on a few of your things, then Moose may be for you. He's a stand-up guy and he definitely wants to be someone's best friend. #adoptable

Moose is available from @RockyMountain AnimalRescue. Fill out an application on their website, naming "Moose the 12 week old puppy."

This is Titan.

Titan is 1 year old. He's extremely friendly, yet independent. He's giant, yet gentle. He gets along with everyone and wants everyone to have a good time. He can play-wrestle a whole pack and also hold a conversation with a horse. He's really, really ridiculously good-looking, but knows there's more to life. He can do leash or no leash. When he plays in a group, the others look to him as the leader of the pack.

If you know someone looking for a born leader built from humble beginnings, please tag them so they can meet this modest fellow. Titan is staying at @garciarescue in Cochrane while he waits for his humble human to realize they deserve him. #adoptable

This little scamper is Cyrus.

She's a half-year old. She's beautiful. She's full of P and V. She loves being cuddled in human arms, and also chewing on them.

I picked Cyrus up early yesterday morning from @pawsitivematchrescue in Calgary. She's currently looking for a foster family, and then her adoption will be through Pawsitive Match as well. She's only a puppy, so she wasn't that helpful with her picnic packing. I fitted her with a harness with the same ease that a mother fits a tantrumming 2-year-old human into her outfit. Or maybe it was more like dressing a snapping turtle. I haven't done either, so I can only speculate.

Cyrus was the most excited of all the sleepy dogs at my early morning shelter wake-up.

We went for a big hike for a little pup, so I carried her for the trickier parts. When picked up, she melted in my arms and held on for the ride like the best passenger. At the first few encounters with creek crossings, she was careful not to get wet, but by the end of the hike she was excited at every chance to touch the magical fluid (and extremely fascinated by the falling water at a small drop in the creek – she opened her mouth to bite the falls and was surprised by it). If you know someone who would love to foster the cutest and silliest little girl, let them know she's at @pawsitivematchrescue. And watch their site for her adoption info. #foster

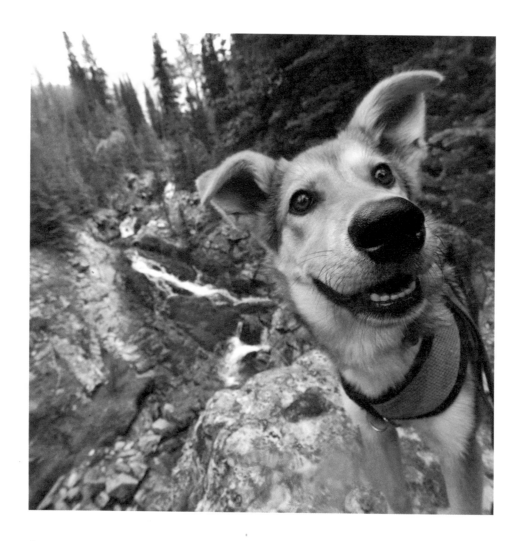

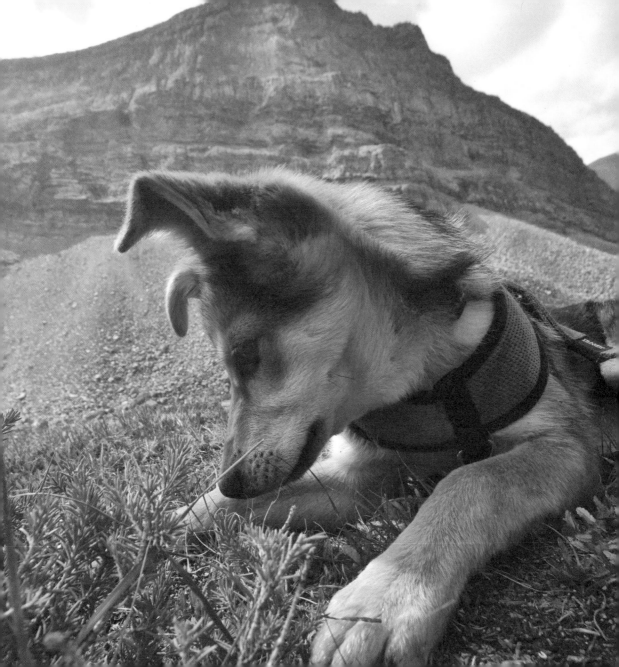

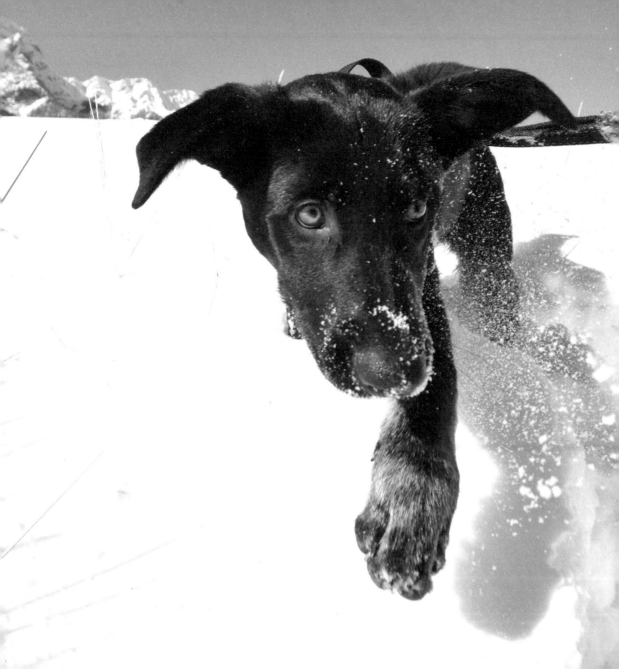

This is Rae. She's about 4 months old and already has a wise skepticism of strangers. She's still a ridiculous puppy, though, so it didn't take much to fool her into being my best friend for the day. Her foster parents (@fosterpupdates) delivered this sweet girl to Canmore on Saturday. The weather forecast for the day was "extreme cold warning," so Rae and I postponed puppy kayaking for a later date. Instead, we packed up cameras, blankets, snacks, drinks and Beans and headed up the gravel road out of the valley and into the jagged Rockies. Rae was hesitant in the car and then hesitant to get out of the car. But once she saw Beans get out, she raced after him. She looked to him as Elder in order to know what to think of the strange things that kept happening. After some chilly photos here and there, Rae became aware that, post–chilly photos, pups get snacks for good efforts. So each time after clambering into the car, Old Beans and Puppy Rae looked to me expectantly, then to my snack pocket. I like it when communication between human and dog is clear enough that each can convey their feelings without speaking. Ideally, humans would do more of this, intraspecies.

After an afternoon of short extreme-cold exposures, Beans, Rae and I came home to prep for old Beans's 14th birthday party. Rae wasn't helpful (fully meeting my expectations). She was pretty sleepy after a day of new things. If I sat down anywhere she had access to, she climbed on top of me to claim me and close her eyes for a moment.

Do you know someone looking to add a pup like Rae to the family? She's currently relaxing at her foster home through @arfalberta, waiting to start her life with her forever team. Apply to adopt Rae on the ARF Alberta website. #adoptable

Thank you Emilie and Craig (@foster pupdates) for continuing to give these tiny homeless hooligans a loving place to call temporary home.

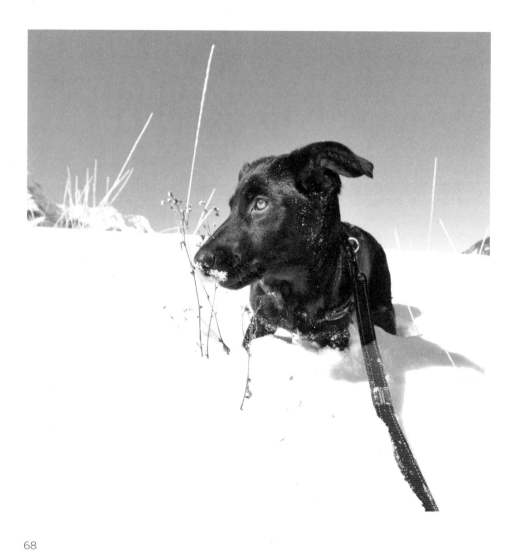

This is Poppy, a.k.a. Max.

He's about 4 years old, and I was told he's never been on a hike before. I was also warned about Poppy's neurological issues; he has seizure episodes that present themselves as him biting uncontrollably at the air. I was thus warned not to put hands or face in front of his mouth in case he has an episode.

I immediately witnessed Poppy have an episode in my car en route to our hike (see car video). I had leashed him in the back, as instructed, for everyone's safety. I learned a lot about dog seizures this year, as our own Denali started having them; they aren't as serious as in humans, and dogs "bounce back" very quickly. It's scary and confusing for the dog, so the best support is a calm presence without restricting their movement.

That was the last I saw of Poppy's episodes. (He was undoubtedly stressed in a stranger's car.) Once we started our hike Poppy was *ecstatic*! He decided without hesitation that he loves hiking and me! I slowly let my guard down and we had many hugs. Poppy was really excited to see the water flowing in the creek and took many

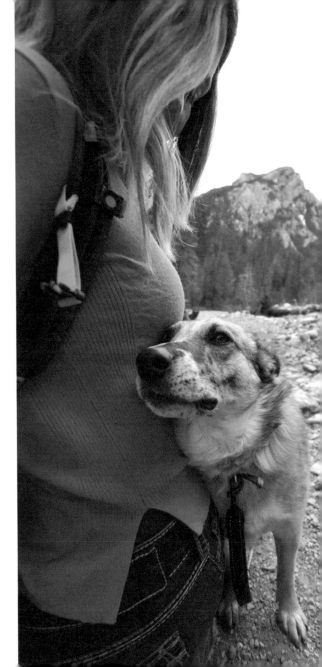

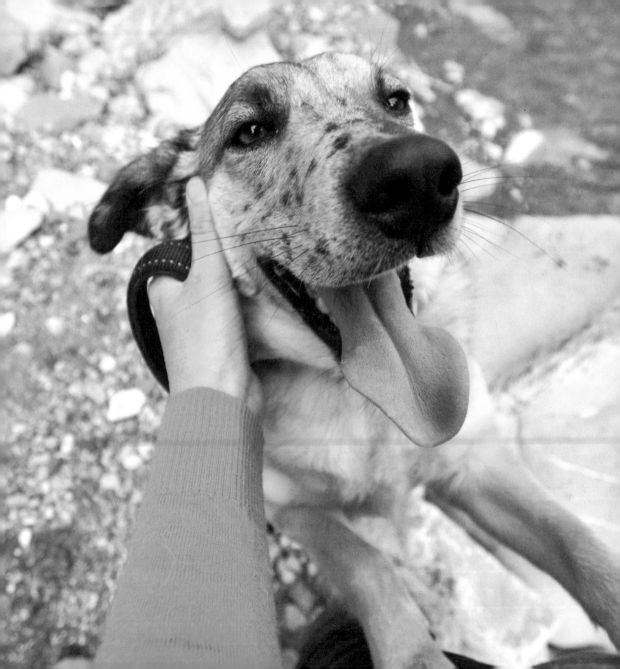

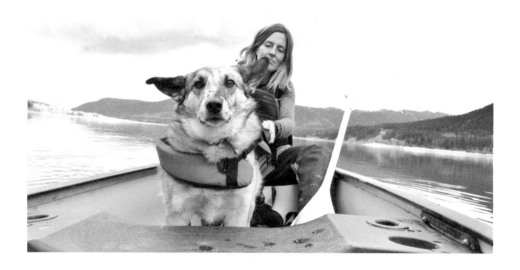

opportunities to drink. (Hydration is also important after seizures.) His balance isn't great, so obstacles on the trail that might ordinarily seem small took Poppy some figuring. I could see that what motivated him was getting to me. He's the sweetest, most loyal stay-by-my-side dog I've met in a long time. He's good with cats and likes to play with other dogs (as long as they are accepting of his quirks). Poppy has no desire to hurt anyone, but since he can't control his seizures, he won't move into a house with any children.

Even though everything I was told about Poppy was true, it doesn't define him. Yes, he needs a special human who understands his quirks, but he brings so much more to the table than he needs in return. It's rare that anyone makes me feel as much as Poppy does.

If you know someone who would love and appreciate this boy for the very special dog he is, let them know he's available for adoption from Rocky Mountain Animal Rescue. #adoptable

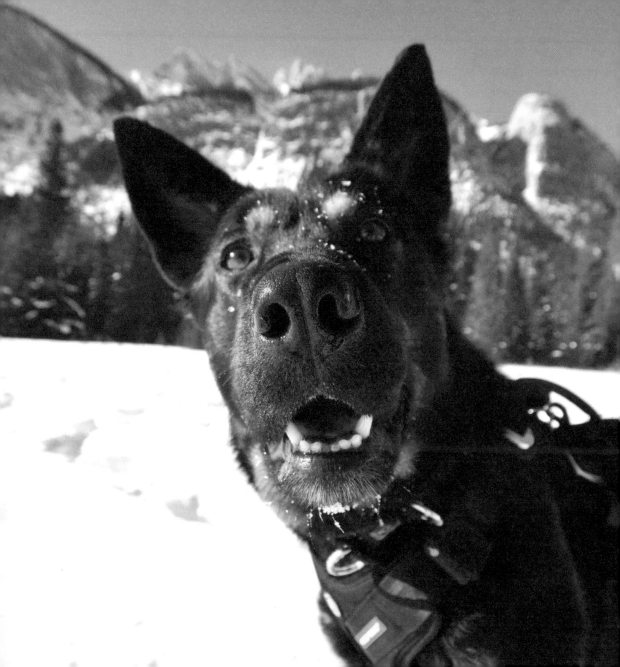

This is Jacs (as in Jacqueline).

I met her last week at her new accommodation: Rocky Mountain Animal Rescue. She was excited to say hi to me, but in all the action that day, I didn't have the chance to return the welcome she deserved. To make up for my hasty passing, I returned and picked her up from the shelter yesterday. I'm 99 per cent sure Jacs hasn't ridden in a coupe before. She wanted to get in, but couldn't seem to figure out the loading method expected of a pup like her by Honda. I lifted her front paws in and she clumsily dragged the rest of her body to follow. After learning how to get in that first time (and figuring how to get out – that terrifying 30 cm step to the ground took her a moment to conquer), she was a pro. She eagerly got in and out of the car at every stop, showing how smart and adaptive she is. We toured Banff: mountains and mostly-frozen waterfalls. We even precariously traversed the frozen surface of the turbulent Bow River. Jacs checked in with me several times while crossing the ice on the raging Bow to be sure I did a full risk assessment and structural analysis of the dynamic freezing and thawing systems. (I had that familiar feeling: "This dog is smarter than me.") We made it across – twice, both lives intact. Jacs likely attributed this success to the good fortune she's experienced in making it this far in life.

When we stopped to meet Beans in Canmore and have a bite to eat, Jacs slithered down the stairs like an extremely athletic pup who hasn't ever negotiated a set of stairs before. But as with the car, it only took once to learn how to negotiate this strange man-made contraption. Everything Jacs learned with me was done with grace, good humour, and humility. She's a very smart, happy girl who's eager to learn about the world around her from anyone who has a minute to show her how it works.

If you know someone who would love a kind pup with a steep learning curve, tell them about Jacs. She's waiting at Rocky Mountain Animal Rescue for the perfect loving and knowledgeable humans to adopt her as family. #adoptable

This is Bronson.

He's 18 months old. I met him this week at his foster home in Calgary where he's couch surfing. He seemed happy about everything and unaware of his current housing predicament. #fosteringsaveslives

Bronson guided me around some of the amazing gems of nearby Bragg Creek. We sniffed all around at Elbow Falls and along some precarious drop-offs. We saw a couple of dogs at the falls that Bronson was quite drawn to. I told him today is about finding permanent humans, not gallivanting and playtime. He said ["That's not fair"]. I said, "Welcome to life, bud." When you're adoptable, you're not allowed to play with all the dogs; you have to wait until you have a family for that. #themstherules

We continued down Highway 66 to Cobble Flats, where Bronson brought me along for a bout of varmint tracking. We plowed through the trees and brush in places where we found no sign of any humans. Bronson is either experienced in tracking or it came pre-wired in him. He found a cut bone that made him very happy (only to have it taken away by me). #dreamcrusher

We moseyed up to the hiking trail up Prairie Mountain. The elevation gain was fast and we were soon greeted by amazing views from both sides of our ridge walk. We chewed on some appetizers (licorice and dried liver) while we visually digested our surroundings. We shared a turkey sandwich, then PB&Js for dessert. Bronson was content and relaxed now. He laid on my feet and watched me as I fiddled with technology. He was relatively gentle on the steep descent (for a big fellow named Bronson). Every time I said "whoa, Bronson" or "easy, Bronson," I heard myself and felt as if it was a silly request. Even so, at each request, Bronson stopped and waited for me to clamber down to his location.

Do you know someone who would love this goobery brindle tiger? His adoption is through @aarcs in Calgary. Contact them today to meet this big lad. #adoptable

This is Phil.

He didn't come with a name, so I called him "Phil" after a human friend who's pretty near as cool as Phil the dog. Phil (the dog) is something like 2 or 5 years old (my expert testimony), but he's carrying about a century's worth of dirt in his fur. He doesn't realize it, but he would love a volunteer to come and take him for a spa day; his hair and nails need a little attention. It may not feel like Type 1 fun (for anyone involved in this adventure), but Phil will appreciate how fluffy and nimble he feels afterward (bonus: it will make him a much more eligible adoptable). Phil hasn't had the luxury of being welcomed into anyone's home or car much, so he's learning that these can be safe (even fun) places for a pup like him to spend his time.

Phil has a couple of million hugs that he's been saving for when someone is willing to take them. Do you know someone who would love this affectionate, happy, eager guy? He's available for grooming, fostering or adoption from Rocky Mountain Animal Rescue #adoptable

This is Oscar.

He's 9 months old, his back end is a little wonky, and he was found in a dumpster – so it's a really good thing he doesn't take life too seriously.

To get him into the kayak, I told Oscar that other dogs love to go kayaking. #thatsmisleading but Oscar didn't know any better. Oscar is fearless and will try anything other dogs do. He was perfect during dry-land training; I wasn't. If you think lying to an innocent (and very trusting) young pup about dogs' affinities to kayaks would make a person feel bad, you should think of it relative to (accidentally) catapulting him out of a kayak during dry-land training. Oscar looked surprised when that happened. I'm pretty sure the sight of this sweet boy with a wonky back end being tipped out of the kayak scarred onlookers for life, but this is exactly the kind of thing that can happen when you're trying new things and exactly the kind of thing Oscar's forever human won't take too seriously (and let it ruin a perfectly satisfactory time). He wants to try lots of new things and he doesn't want to have to reassure someone every time "something" happens. So I tried my best not to take it too seriously (even though I felt like the worst human in the world) and continued into the water.

Much to Oscar's relief, our paddle was a lot less eventful than our dry-land training.

Oscar's mobility has gotten progressively better while he's been in foster care. He is one of the happiest pups I've met, willing to try anything once, and he comes with loads of character (inevitable with a life like his to this point). Oscar met Beans after our paddle; Anna refused to meet him calmly, so she was denied (that's just too much crazy for one day). If you know someone who promises not to cry over a wonky back end, who doesn't let a challenge get in the way of a good time, and who would love a loyal, fearless boy, let them know about Oscar. He is at @aarcs dreaming of a life of adventure with someone super fun like himself. #adoptable

This is Alpine.

She's 13 weeks old now, but her adoption photo adventure has been going on since she was just 12 weeks. My friend Matt (@mattscobel) and I picked up Alpine last Friday from @garciarescue in Cochrane. Matt is an amazing photographer and he loves dogs. We had big plans for an evening adventure for Alpine in Kananaskis. We wanted to help find Alpine the perfect home.

Matt held her as I drove; she didn't want to be anywhere else in the car but with him. I'm not sure if she meant to, but she melted the grown man's heart in seconds.

I'm a bit immune to the cuteness of silly puppies, but Matt isn't. Alpine talked him into a sleepover (which turned into a few sleepovers) before we even got to K-country. We explored a beautiful creek where the small rock features were huge obstacles for a pup her size. She met Beans and Denali, camped with Matt, went kayaking, hiking and swimming. Every new challenge was sized up, strategized and overcome. She impressed even me, while Matt was already sold.

He was going to keep her. He was looking for available insta-handles for her. He was planning their vacations together while admiring all her little fur markings. Only one problem: Matt can't have dogs where he lives.... I could see how hard this was on him. He (and Alpine) seemed to know that they were already family. He never stopped thinking of ways to make it work. A week later, after many hoops were threaded, Matt officially got the OK to adopt! I'm beyond happy for Matt and Alpine Scobel. May you have many beautiful adventures ahead, with full hearts and empty camera batteries. I cannot wait to watch it all unfold. #adoptable #notadoptable #shepickedhim

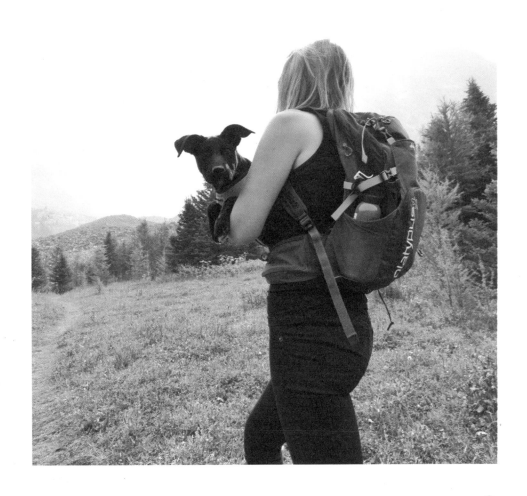

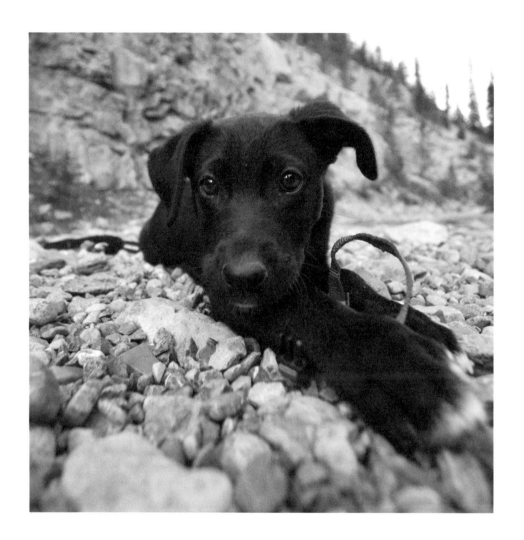

This is Moon. She's a 2-year-old cuddly puppy trapped in the body of a small rhinoceros.

Moon jumped into my car and we drove west. I'd heard that Moon might try to embarrass me if we encountered any dogs, so (bashful as I am) I drove until we found a hike with no one parked at the trailhead. We did pretty well on the crusty, slippery, snow-packed ascent, for two large tethered animals with no previous experience hiking while attached to each other. I felt Moon could have omitted a few behaviours from her team hiking repertoire – namely, the vigorous launching of herself from the trail down steep banks of crusty snow (with me at close to the same weight on the other end of the leash).

We did encounter a dog with two humans on our descent. I saw them coming and I told Moon, "Okay, this is your chance to show how calm and collected you can choose to remain." I hooked her leash to a tree and told the other humans (in code) what the possibilities were so everyone would stay safe but she'd still have a chance to prove herself. When I said we

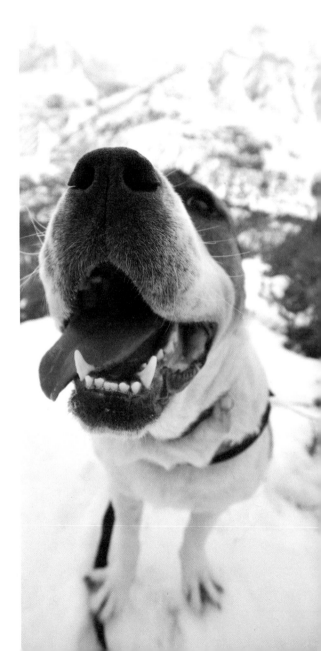

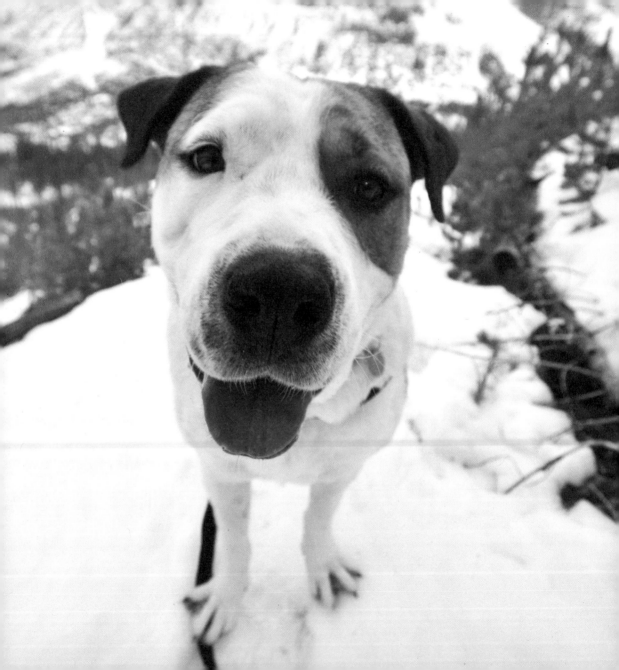

were ready, they walked by with their pup – and what a show of composure ... from the three of them. As they passed, Moon and I flipped upside down and spun around and made lots of struggle/bark-type noises as I also tried to carry on a calm conversation with the other humans – Moon testing the strength of her leash and the tree (glad I let the tree do the work), the other dog walking by watching her curiously. It's safe to say she could benefit from some social skills training from her adopter.

Moon is amazing. To make up for her lack of grace, she loves her humans more than any human can ever deserve.

If you know someone who would love this xL happy girl, she's waiting so patiently at @aarcs (taking none of the cuddles from staff and volunteers for granted). #adoptable

This is Rambo. He's 7 years old and he really really likes meeting new people. Even with my extra-crazy-dog-lady enthusiasm for dogs, Rambo came on stronger than me. He just can't contain his excitement (and I would never ever want him to). Once Rambo put me, @mr_nice_guy79 and Beans officially into his mental Rolodex, he was able to exist at a level where he could walk around and lie down and potentially have a nap (to exist like a happy dog). Before that moment, though (the moment when we moved from strangers to familiars), Rambo was like a hot (bouncy) molecule with a voice box.

Rambo came to Canmore for a sleepover, where he spent most of his time in the kitchen. He has a useful nose for finding available snacks. If said snacks are unreachable for a lad of Rambo's stature, he gently asks for an assist.

We went to the mountains for an adventure, which consisted entirely of carrying Rambo wrapped in a blanket to smell and pee on things, then back to the car. It was −30°C, so Rambo happily let me wrap and carry him anywhere. We saw a gaggle of bighorn sheep and some fresh mountain lion tracks. Rambo didn't much care about that stuff; his feet are extremely sensitive to the cold, after someone left him in the woods a few winters ago (but Rambo doesn't let this stop him from loving and trusting everyone).

At bedtime, Rambo likes to sleep in the biggest dog bed (which happens to be the one we sleep in), but he makes himself quite compact.

As a 7-year-old boy sleeping in a new house with strange people (plus a Beans), Rambo acclimated all the way. If my memory were just one level worse than it is, I'd think, from his routine ability to communicate with me and "operate" me, that he's been here all along.

Do you know someone who would love this super-smart, ham-shaped boy? What he lacks in physique, Rambo more than makes up for with enthusiasm. He's available from @beaglepawsnl, Calgary Chapter. #adoptable

This is Wyatt.

He's 6 months old and he's very good looking. Foster mom @liorabeaulieu loaned this silly puppy to me for a day over the weekend. Wyatt listened to me go on about his name en route to Banff, where we were going to go for a little paddle. When we got there, we discovered that the last open water had frozen over. Just to be sure it was too thick to paddle through, I tested it. I showed Wyatt the fastest (though not the smartest) way to test ice integrity: walk on it. Usually I poke at it with a stick and then, based on the information gathered, maybe cut a hole with an ice screw – both the walk test and the stick + ice screw test are effective for checking whether the ice can hold a human. The test conductor should use the stick + ice screw test unless dressed in a dry suit and PFD or mentally prepared for a refreshing stimulus.

Wyatt took in all the test information and decided not to do the walk test. We went to my house for some dry boots and trousers, then drove to a different place, where I knew we could paddle. Beans and Denali came along to watch how Wyatt performed in his

debut role of anything-but-capsizer. Slightly disappointing human and canine onlookers, Wyatt did not capsize us. He was an inquisitive yet low-maintenance passenger. Once we reached terra firma, he seemed to carry himself with a new joy for life.

He was excited to be reunited with Beans and Denali and tell them many things on a walk by the lake.

If you know someone who would love to add an empirical decision maker to their family, let them know that Wyatt is a keen observer and critical thinker. He's #adoptable through @arfalberta.

This is Shadow. She's the quietest 1-year-old I've ever met. She doesn't seem to have much experience with people, cars or stairs. Though she was really unsure about getting into the car, she did when I asked her to. She sat on the floor for a while, not sure whether she should be on the seat (even with the obvious layer of dog fur in my car from those preceding her). Eventually she found a place to lie down and wait until the next thing happened that she needed to address.

She was happy at the mention of getting out and going for a walk, but when I took a couple of steps into the deep snow I realized she wasn't agreeing to follow. ["No, thanks"]. We got back in the car and drove to a trail that I knew would be packed down by those trusty snowshoers. She led me all the way to a beautiful frozen waterfall, and we didn't run into a single soul apart from a squirrel (the only thing that caught Shadow's attention and the one time she veered off the beaten path). After our hike and meander around Lake Louise and the Bow Valley Parkway we went to see if she'd like old Beans and Denali.

I'm so glad we did. She wagged her tail and her eyes lit up for the first time. She really liked @mr_nice_guy79 and even asked him for more cuddles when he relented. And once she saw that Beans and Denali didn't mind me, she didn't mind me either. When her foster parents showed up (whom she's only known for a week), she got visibly excited. It made me feel to see her so happy after a long day with me actively being unsure.

If you know someone whose pure love would allow this sweet girl to be herself, please let them know she's waiting with her foster mom and dad through @aarcs in Calgary. #adoptable

This is Ellie. She's a young pup of less than 2 years. I met up with her for a Sunday drive and hike (on Sunday). Ellie was pretty excited to get in my car but more excited to get out when we arrived at the lake. I wanted to show her one of my favourite trails ever. It's a wormhole that whisks you far beyond the Banff crowds in any season. I've seen people hike it, but I've never done this trail without my trusty mountain bike (it eliminates the pesky business of hiking). Ellie definitely would have preferred me on bike rather than foot. She had the energy to travel many kilometres farther, much faster than me in my tip-top hibernation shape.

Ellie met a few oncoming hikers, many commenting on how amazing and gorgeous she is. Because I think it's important to advocate for the voiceless, I'd reply that "she's actually a lunatic." To be fair, that's a bit of an exaggeration; Ellie is probably a little nuts, but she's not certified. She's very sweet and wants to do exactly what you want her to do. Ellie often looks to her person for approval (or instigation ... she loves some roughhousing instigation). If

you know someone who would love Ellie and could keep up with her on the trails, please let them know she's ready to go. To get more info or to apply to adopt Ellie, visit @aarcs. #adoptable

This is Kroeger. I didn't get this little stinker's age when I met him, but after spending a few days together I'd gauge him as somewhere between silly puppy and immature juvenile. The good folks at Alberta Animal Rescue Crew Society likely have a more scientific estimate involving a numerical descriptor.

After enduring a touch of the mange, Kroeger just officially acquired a clean bill of health. He loves having lots of friends, but those mites were just freeloaders. He's in the market for some fun sweaters to get him through the next couple of months and some new friends who preferably don't burrow into his skin.

I'm not sure what Kroeger found to roll in, but he must have found a lot of it. He was emitting stink waves that were detectable with three, maybe four, of the human senses. @mr_nice_guy79 and I took him to our local car wash to hose him down. (One of the perks of living in a dog-loving town: there's a dog wash room at this car wash.) After bathing, a Kroeger cuddle became a highly sought-after event. Also, Beans stopped leaving the room when Kroeger walked in. The pup was happy to visit with Beans and Denali, but he really wants someone less geriatric to paw and mouth at.

Do you know someone who's been searching for a fluffy, playful, adventurous pup like Kroeger? Please let them know that Kroeger is waiting for them at @aarcs. #adoptable

This is Gunther. His soul is old geezer, but his body is only 2. He takes each step with thoughtful hesitation (much unlike any other 2-year-old I know, canine or human). He's been recently porcupined and then neutered. It's been a rough December for Gunther, and it shows. But things are looking up: he's all fixed up and he met a nice lady, Stephanie (@recordstephanie88), who put him on TV (even with a face made for radio #porcupined).

Gunther came with me to help with an interview explaining my crazy dog lady thoughts. I do have a lot to say on why I do

what I do, but the thoughts always refuse to come out of my mouth in the right order. I figured if I just showed a cool pup like Gunther, everything would just be obvious (eliminating the need for verbal articulation). Well, Gunther wasn't really interested in being on TV, even if it was for "the greater good." He kindly let me do all the talking. The interview was played on CTV news all over Canada. (I'm really glad I didn't know that when I was standing alone in front of a camera.) It was very exciting for Gunther and me; we went to relax in the mountains for a couple of days. For morning walk, Beans and Denali eagerly hauled Gunther to one of their favourite spots. Then we set off to explore Banff. Gunther took three steps out into the ridiculous wind storm yesterday and told me in no uncertain terms he'd be happy to wait in the car. So we explored Banff in the least efficient way: by car.

Do you know someone who likes to go on walks (but not in uncomfortable weather), relax by a fire and give belly scratches, and who makes a good breakfast? Please let them know Gunther is trying to find

them from his temporary home: @aarcs. He's at a huge disadvantage in his search without a way to communicate, so please let your fair weather explorer friend know about him. #adoptable

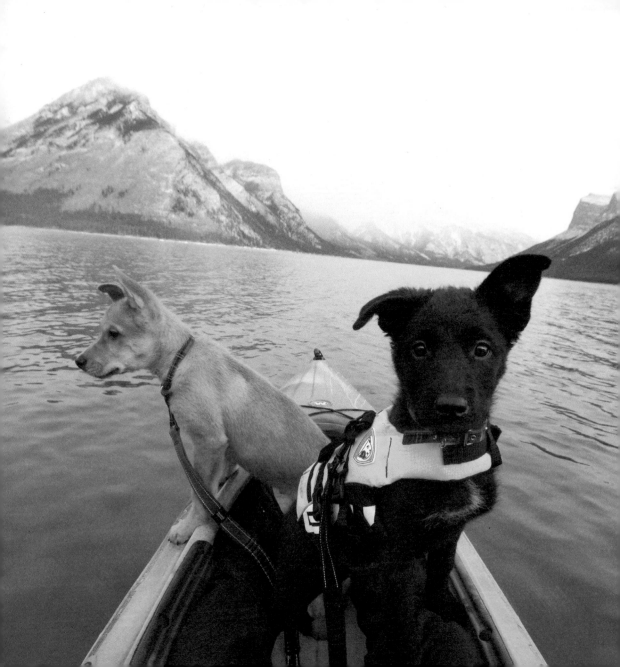

This is Bonnie (black girl) & Clyde (blonde boy). These ridiculous sub-3-month-old puppies are living in downtown Calgary temporarily with their foster humans Emilie and Craig (@fosterpupdates). Though they are extremely silly puppies now, they aspire to be more. I warned them not to grow up ("It's a trap!"), but they seem determined. They already know how to kayak, which made kayaking with two silly puppies much easier than it sounded when I pitched the idea to myself. They sit and (sort of) stay. They can also lick faces of children when specifically asked to do so.

These silly puppies have the explosive energy and finite stamina of an American football player. After each burst of excited acrobatics, they take a nap to recuperate.

Do you know someone who would love a silly puppy (who will inevitably turn into a dog one day)? Bonnie and/or Clyde can be applied for through @arfalberta. #adoptable

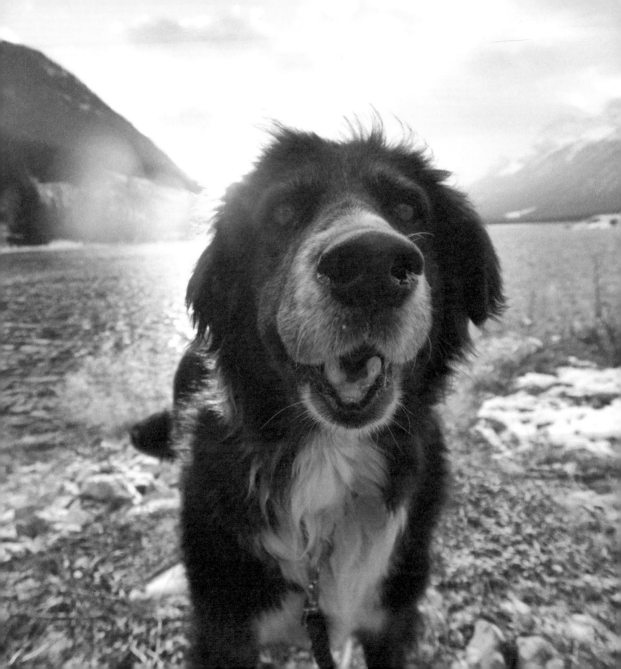

This is Garrett. He's somewhere near a decade old, but he's of the opinion that age is just a matter of mind ["if ya don't mind, it don't matter"]. His foster humans drove him to Canmore this week to spend a couple of days with a strange lady and two even stranger dogs. Either the new situation bothered him not a bit, or Garrett is the best bluffer I've met. Beans and Denali are used to meeting new pups, but not usually pups as experienced as Garrett. Garrett has many years under his collar, and he is wise beyond them. He's slow to excite but quick to smile. He appreciates the little things like a cozy bed and the return of his human after any separation. He loves dogs and humans (and I would speculate even cats). He seems to love anyone who will join him for a walk or a nap without prejudice (#evencats?). If you know someone who would love a napping and walking partner who rarely relents from smiling, tell them about Garrett. He's available for adoption through EJ Rescue Canada in Airdrie. @ejrescuecanada #adoptable

I'm so happy to meet amazing humans like Barb and Bob who open their home as a loving foster family to dogs like Garrett who (through no fault of their own) end up needing a temporary place to stay. If you'd like to foster, there's a very good chance your local shelter would love to hear from you. #fosteringsaveslives

This is Mia. She's 2 years old, which is old enough to ride shotgun if you're a dog. Mia has some really creative ways of occupying the front seat; her mere presence is enough to keep one from the ho-hums.

I picked this anxious snuggler up from the Calgary Humane Society yesterday. She's not shy, but she sometimes lets her nerves run the show.

We went hiking in Kananaskis, where some fun trails are opening back up after a long winter. She seemed as delighted as I was about the fresh air and melting snow. After our hike, I left her in the car alone for 30 seconds to use one of the luxurious wilderness restrooms. She was pretty upset that I didn't take her with me. When I got back in the car she acted like the pups you see in online stories where dogs get reunited with their human after losing them for years. She cared much more about my presence (and absence) than I could imagine.

Mia curled up in a tiny pancake in the front passenger seat and slept on the way back to the shelter. Whenever I reached over to pet her, she would put her chin on my hand to keep it from ever leaving her.

If you know someone who would love a sweet girl who's eager to love someone more than they've ever been loved, let them know about Mia. She's available for adoption from @calgaryhumane. #adoptable

This is Zach. He's a puppy. He doesn't know what he wants to be yet when he grows up, but whatever it is, he wants to be the best one.

Zach is a puppy rep for pups of four litters who were all born from moms who were living stray in northern Saskatchewan. If you're looking for a puppy, please remember that you can adopt a blank slate rather than ordering one up custom from a breeder. These puppies come with all the potential of a crisp new notebook; the possibilities are endless and are limited only by the creativity and ambition of the author/artist.

If you want to apply for one of these pups from the north, head to Rocky Mountain Animal Rescue's website. Some do have applications, but some are waiting. #adoptable

This is Koda.

She's about a year old but she's already smart enough to know that people shouldn't be trusted. Unfortunately dogs don't learn a thing from books; it's all from experience.

Our new pup Anna came with me to get Koda from Garcia Rescue. While Koda seemed happy to be with another pup (even though Anna is rude and took shotgun in the car without even offering first), she sat quietly shaking in the back seat while Anna rode up front showing no sign of intraspecies empathy (much like her human). During the hike, Anna pulled me with all her might while Koda lagged behind, seemingly okay as long as I didn't cast any attention at all in her direction. When Koda became a little less uncomfortable, I paired the DSLR (which terrified her at first) with snacks so that I might take a more natural photo of her. For a fearful young girl, she did better than expected in the weird situation she found herself in (walking through strange woods with a strange dog and human). This sweet girl would definitely be happier to see me next time after I was paired with dried liver rations for the duration of this encounter. On the way back to Garcia Rescue, Anna opted to sit in the back with Koda, who seemed much more relaxed with her new bud.

If you know someone who knows the value of working to gain trust and the bond that this can build, let them know that Koda is available and is looking for someone smart like her. Koda may never trust a cat, so she's hoping to find a great home without one. Find her at @garciarescue. #adoptable

This is Blake.

I was invited last month to an event at @calgarylibrary celebrating the @empathypawject. My reaction to this invite was opposite to my normal social gathering invite reaction: I knew I definitely would go. This project is one that I've watched unfold in joy on Instagram. Ms. Carruthers is an art teacher who mixes painting and adoptable dogs to affirm the kind values these grade 4 students already had in their hearts.

The event took place Saturday evening in the newest and fanciest library in Calgary. I asked the perfectly normal question "Can I bring a homeless dog with me?" The query was run up the chain of command and someone said yes. So I started looking for an adoptable dog whose interests include reading, fancy architecture, meeting many humans of all ages, being quiet for extended periods of time, sitting still, and generally just not embarrassing me. Coincidentally, this is Blake's exact list of likes.

He's almost 7 months old and available to live at your house for the rest of his life. He's so well behaved that whenever I told people he's almost 7 months I was looked at as if I were a crooked car salesman misrepresenting mileage. Blake is currently being fostered by the fine folks at @muttleycrueyyc and he's available for adoption through @aarcs. #adoptable

As if the artists hadn't already presented an art show that exceeded all expectations, an Empathy Pawject artist presented me with a portrait of Beans that perfectly captures his gooberness.

This is Bill.

He's the strong silent type. He's only 2, but he acts like a grown-up. Bill is a calm and confident dog who's particular about his company. He's an introvert. It takes a while to prove to Bill that you're okay people. Whether I am or not, today wasn't enough time to convince Bill. He's a no-fuss kinda guy; he doesn't want to waste time getting to know everyone. Making new friends is not the most fun thing he can think of doing. He would love to have a small circle of extremely awesome friends he knows well and can count on.

Bill reluctantly joined me (I lifted him into my car; he didn't resist or help) for a drive to BC. We hiked the lower section of a trail until avalanche risks prohibited wise dogs like Bill and somewhat informed humans like me from proceeding. He wasn't amused anytime I stepped into deep snow to play, and he consistently exercised his right not to join me in said deep snow. Bill did, however, allow me to hug and kiss him as much as I wanted while on sturdy, packed trail. At first he'd ignore me when I called him, but then he'd relent. ["Fine"], he seemed to say as he'd manoeuvre closer to me. Hugging Bill on trails added to my day – I hope if I ever see him again, he reluctantly agrees to more hugs. If you know someone who would love a strong introvert like Bill, let them know he's #adoptable at @aarcs.

This is Mikey.

He's just been diagnosed with a condition that has forever altered his life, but having a label for it now doesn't make him feel any different. Mikey has a small cerebellum because it never fully developed in utero. The condition, called cerebellar hypoplasia, presents itself as a wobbly walk and bobbly neck. It's not painful, and Mikey's outlook on life is the same as most puppies': he has no idea where he is or what he's doing, but he's quite happy about it. Mikey loves to play, especially with other pups, and doesn't let his human get too far away before chasing.

We went for a kayak in Banff, where he went through dry-land training and then, immediately after launching on the lake, climbed out of the kayak into the water. He swam like a champ, but I hauled him back into the cockpit anyway. He seemed happy to stay inside the boat from then on. We went to the less visited side of the lake and got out for a walk. He stared thoughtfully into the distance as a relatively heavy male loon yodelled (to defend his mating area) and geese honked (mostly to admire their own noisemaking abilities). He demonstrated his ability to run and hold his head steady, impressive feats even for a pup with a well-coordinated hamster on the wheel.

If you know someone who would love an eager-to-learn pup with a small cerebellum and a (figuratively) enlarged heart, let them know about Mikey. He's available from Rocky Mountain Animal Rescue. #adoptable

ABOUT ME

I'm a Canadian artist, dog lover and simple outdoors person. Maybe not in that order. First, I'm a dog lover. I love our two pups, Beans and Anna, so much. When they need a recovery/nap day, I try to help other dogs find homes as cozy as Beans and Anna's. I've been learning everything I can about adoptions while volunteering. My goal is to help improve the system in any way that I can discover opportunities. Currently, there is huge untapped potential for rescue organizations to create the volunteer role "adopt for a day" and for the improved use of social media. This is a free platform that can reach many potential volunteers, adopters and foster homes at no cost to shelters.

I live in Canmore, Alberta, where I work in a restaurant, create local art, and volunteer dog-walk (this takes up most of my spare time and some of the time when I'm supposed to be working).

I grew up in New Brunswick with a kind, extremely smart mother who tried to never let a thing go to waste and a father who would learn anything he didn't already know faster than anyone I've met. I learned biology, mechanics, business and general tomfoolery growing up in the log home that Mom and Dad built in the woods. I feel fortunate to have had the opportunities I had, even if they were disguised as hard work at the time. I went on to university and earned a BSc, graduating with distinction (I thought it mattered at the time), and I now have a degree in a closet somewhere that says double major: Biology and Psychology.

One thing I learned after going on my way with this degree is that it wasn't going to do much for me (I probably knew that before I got it). I wasn't made for career life. I was raised to think creatively and look for opportunity where others had missed it.

I love kayaking and mountain biking. I'm a minimalist and environmentalist, not a consumer.

I want to change minds and make a difference. Innovation is so valuable but can be perceived as "the wrong way" by many

who like to do things the way they've always done them. I want to help people question the way things are and seek solutions to society's accepted problems. I want the world to be a better place because I was here, in spite of my inevitable footprint.

RESCUE ORGANIZATIONS FEATURED IN THIS BOOK

Here's a list of some of the shelters where I volunteer who were affiliated with dogs shown in this book. Thank you for allowing me to take dogs on these (sometimes odd) adventures in the mountains.

- Alberta Animal Rescue Crew Society
- Garcia Rescue
- Pawsitive Match Rescue Foundation
- Calgary Humane Society
- EJ Rescue Canada
- Beagle Paws Rescue Calgary
- Bow Valley SPCA
- Rocky Organization for Animal Rescue
- Animal Rescue Foundation (ARF) Alberta
- Rocky Mountain Animal Rescue